Hands and feet

Michel Lauricella

rockynook

Morpho: Hands and Feet: Anatomy for Artists
Michel Lauricella

Editor: Joan Dixon
Project manager: Lisa Brazieal
Marketing coordinator: Mercedes Murray
Graphic design and layout: monsieurgerard.com
Layout production: Hespenheide Design

ISBN: 978-1-68198-539-8
1st Edition (4th printing, July 2022)

Original French title: Morpho: Mains et pieds
© 2019 Groupe Eyrolles, Paris France
Translation copyright © 2019 Rocky Nook, Inc.
All illustrations are by the author.

Rocky Nook, Inc.
1010 B Street, Suite 350
San Rafael, CA 94901
USA
www.rockynook.com

Distributed in the UK and Europe by Publishers Group UK
Distributed in the U.S. and all other territories by Ingram Publisher Services

Library of Congress Control Number: 2019940043

Publisher's note: This book features an "exposed" binding style. This is intentional, as it is designed to help the book lay flat as you draw.

table of contents

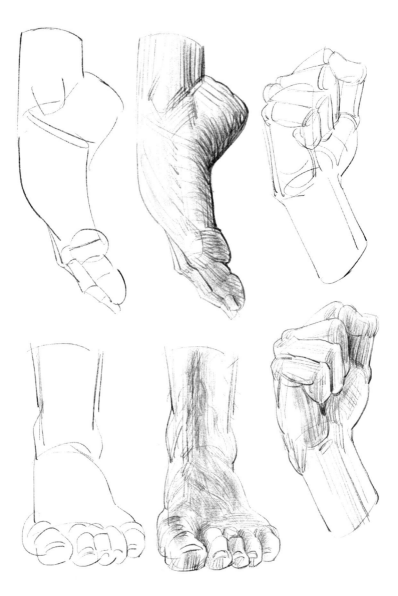

foreword

Drawing the extremities—the hands and feet—is a common source of frustration for artists. Much practice should help you overcome the difficulties, and I believe the lessons on morphology in this book will provide you with a foundation and understanding that will lead you toward success in your art.

To help you on your journey, I have gathered together some of the drawings that were previously published in other books in my *Morpho* series. However, in this book, you will also find many new drawings, specific details, new postures and perspectives, and, in particular, a presentation of the venous system of body's extremities.

The routes the veins take are actually somewhat random, especially at their most detailed level. Therefore, in this little volume, we will focus on a simplified cartography of the veins that is meant to address the mnemonic needs of drawing from your imagination. The veins, as they carry blood back to the heart, become dilated with effort and can become extremely distinct and expressive on muscular bodies that undergo regular, sustained effort. Including such veins is the hallmark of a lively, dynamic figure drawing.

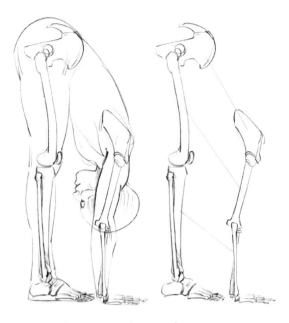

introduction

The goal of this book is to facilitate your drawing from imagination; therefore, you will find a review of human proportions and a simplified presentation of shapes. We first will consider the skeleton, using bone markers. Then comes the musculature, along with the movements it allows. Next comes the skin, along with the layer of fat that is always present, at least on the bottoms of the extremities, and which develops along with extra weight on the tops of the extremities too. Finally, to truly complete our figure, we will discuss the inclusion of the veins.

To review the skeleton and musculature, we need to go back to the forearm and lower leg segments. These overviews of the limbs will also allow you to reacquaint yourself with the proportions in order to reconstruct the connections of the extremities as accurately as possible and to maintain a sense of the complete figure. In addition to studying this book, I suggest that you also pursue drawing from life.

Keep in mind that the upper and lower limbs are built along similar lines. Once the basic forms are established, it is interesting to look deeper for the distinctive characteristics and fine details of each.

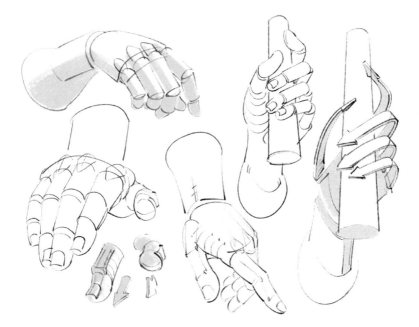

Hands

The hands are quite flexible and they form into the shapes they grasp. In addition, the hands accompany speech, punctuating it and truly illustrating it, when they don't replace speech altogether. Above all, a hand is a pincer. We can find similar prehensile limbs, adapted for grasping, in a variety of animals. A koala's "index fingers" (actually claws) are associated with the human thumb for this function. The same is true for the chameleon, which also has two "fingers" on each front foot that are opposed to the other three, and it has the inverse arrangement on its back feet.

The most common challenge in drawing a human hand lies in the orientation of the thumb. It is often easier to first draw the shape of the object being grasped and then draw the hand that is grasping it, like a true pincer. I will revisit this idea in greater detail later in the book.

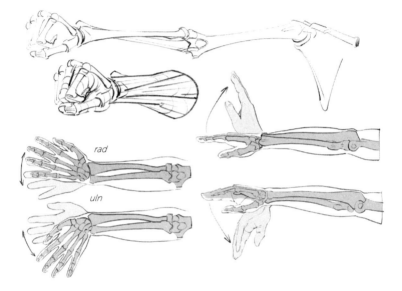

The forearm has a conical shape near the elbow and then flattens out near the wrist. Following the forearm is the back of the hand in a curved or "tiled" shape. Here you will want to pay attention to its nuances, because the back of the hand is flexible and can become flatter or rounder with movement. Each of the four fingers contains three phalanges. On each finger, the first phalange, which is connected to the back of the hand, is equal in length to the next two phalanges together. The thumb has only two phalanges, but its greater mobility starting at the wrist joint means its metacarpal is independent from the fingers and, therefore, gives the thumb the appearance of having three mobile segments.

Bones of the Hand

The forearm contains two bones that make it possible for the limb to flex at the elbow and also for the hand to rotate in movements called *supination* (supporting) and *pronation* (grasping). The bones in the forearm—the radius (rad) and the ulna (uln)—are either parallel or crossed, by rotation. The hand's movements of flexion, extension, and lateral tilting are initiated at the wrist.

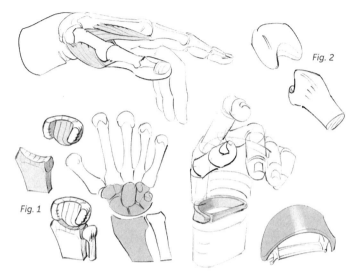

Fig. 2

Fig. 1

Eight small bones make up a base at the wrist (Fig. 1) where the tendons of the powerful flexors are kept in place by a bracelet of ligaments. The whole takes the shape and function of a hair barrette, whose clasp corresponds to the ligament. These eight bones are arranged in two rows, curved along the sides. The curved form of the back of the hand begins here. This arrangement of jointed surfaces is what gives the wrist its flexibility. The entire system, together, is called the carpus; it is jointed with the radius and, therefore, accompanies it in its movements of pronation and supination.

The edges of the carpus can be seen under the skin and make up the shape of the heel of the hand. The thumb is jointed almost perpendicularly to one of these edges, while the other fingers are aligned along its principal axis.

The metacarpals come next. The metacarpal of the thumb is positioned below the carpus through the intermediary of a single joint called a saddle joint (Fig. 2), which allows movement along two axes. The thumb's perpendicular orientation causes it to be opposed to the fingers, and it can easily bend into the hollow of the palm.

The bases of the metacarpals of the four fingers present flat surfaces, one right next to the other. Their movements are restricted. At the far ends of each of these four metacarpals are spherical joints, which make the fingers' movements possible. These joints are clearly visible under the skin when the fingers are closed into a fist.

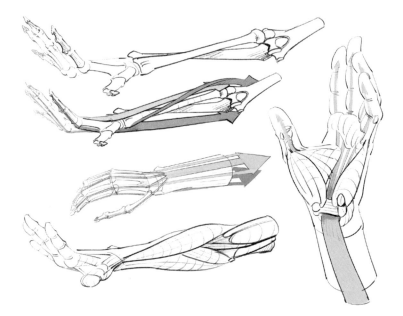

The fingers are each composed of three phalanges. Pulley-shaped joints restrict movement to flexion and extension. The last phalange includes the fingernail and, in order to receive it, is in the shape of an arrowhead.

Musculature

The musculature of the arm includes a set of muscles that is connected at the top of the forearm, at the end of the humerus at the elbow. These are the (more powerful) flexors and the extensors, which begin on both sides of the end of the humerus and are separated along their length by the ulna on one side and the brachioradialis on the other. Along with the brachioradialis (which flexes the forearm at the elbow), the entire muscular system of the forearm serves the purpose of moving the hand and fingers.

The second set of muscles, which completes the system, is contained entirely within the hand. Most important, it allows the thumb and little finger to work in opposition, bringing them together.

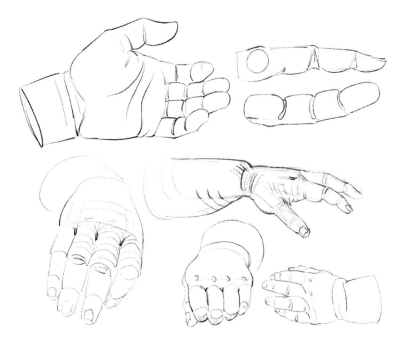

Fat

There are two types of fat at the extremities: *subcutaneous* and *visceral*. The subcutaneous fat that can develop with added weight lines the skin and is usually thickest at the root of the limbs. The fat layer becomes thinner as it approaches the hand. Fat causes the formation of dimples on the back of the hand, at the knuckles, and tends to mask the appearance of the veins.

The fat that can be found underneath the fingers, from the heads of the metacarpals to the ends of the fingers, and on the palm of the hand, is present in everyone. It acts as a shock absorber, and allows the hand to mold itself to the shapes of objects and to adhere to them.

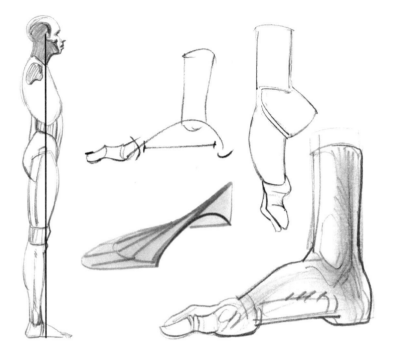

Feet

The feet are constrained by our bipedal stature and, therefore, maintain a more constant shape than do the hands, regardless of pose or angle of view.

The feet support the weight of the body and absorb the repeated shocks of walking, running, and jumping. The feet also absorb the weight of loads we commonly carry in addition to our own weight. The role our feet play is, therefore, to establish a zone of balance and to cushion impact.

I find it much easier, morphologically speaking, to organize the drawing of the foot around the vault of the plantar arch. The summit of this arch is in line with the body's center of gravity when in a classic standing position. The empty space under the foot allows it to flatten or collapse like a damper blade. You will find, later in this book, drawings of feet that are more and less dymanic, including flat feet. The various shapes will allow you to give your drawings character.

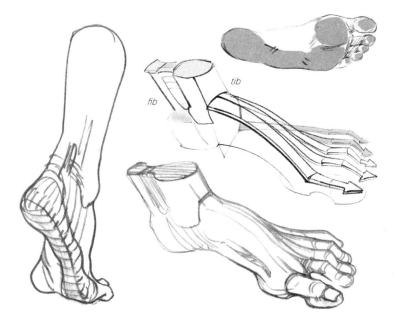

Simplified Shapes

Like the forearm, the lower leg is more or less conical, and narrows toward the end. Once again, the fleshy masses are positioned higher up on the limb, and the tendons become more prominent as we go down the leg.

The top of the foot, too, is curved, and it also tilts toward the outside. Think of the imprint a foot leaves on the ground: You see a continuous connection along the outside, but it is broken underneath the plantar arch on the inside. To complete its arc, the arch has to be extended behind the ankle joint by the sturdy heel bone. We find the same number of segments in the toes as in the fingers, including one fewer for the first one—the thumb and the big toe, respectively. Here, our drawing is simplified by the alignment of the five toes as they rest on the ground.

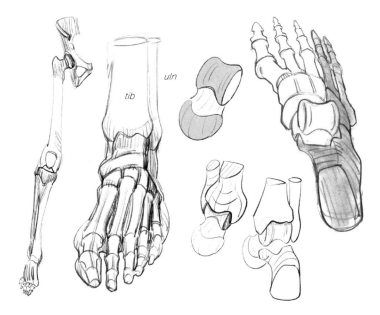

Bones of the Foot

The lower leg, like the forearm, is composed of two bones: the tibia (tib) and the fibula (fib). These bones remain parallel and are not able to cross as with the rotation of the forearm. Together, they make up the ankle joint, which corresponds to the "pulley" of the talus, the first bone in the tarsal series, which they complete by descending along its sides.

Next are the bones that make up the top of the arch. In shape and function, they mimic the blocks you'd find in an architectural arch. The keystone of the arch is the navicular bone, which can be seen underneath the skin on the inside of the foot.

We distinguish between two parts of the foot here. The first is the dynamic, arched part, which includes the talus, the keystone, and three small cuneiform bones that correspond to the first three metatarsals. The second is the static part, used for support, which rests on the ground along its outer edge. This is made up of the calcaneus bone (the heel), the cuboid bone, and the two outer metatarsals. Finally, the phalanges of the toes present the same characteristics as the phalanges of the fingers, and here again, there is one fewer phalange on the big toe (corresponding to the thumb).

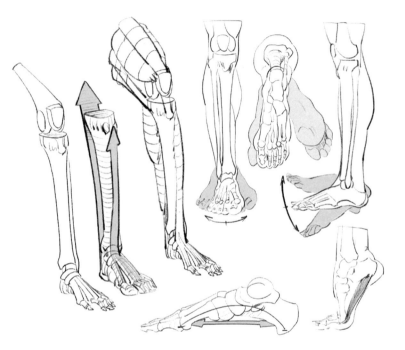

Musculature

As is the case with the upper limb, the muscles that are inserted higher up on the bones of the leg are what move the foot and the toes. They work in relay with the foot's own muscles. One muscle deserves particular attention: the abductor hallucis. I have emphasized the plantar arch and its role as a shock absorber. The "string" of the arch's "bow" is the abductor hallucis muscle, which gives it elasticity. This muscle starts at the heel and connects with the first phalange of the big toe. It can be seen on the inside, underneath the arch.

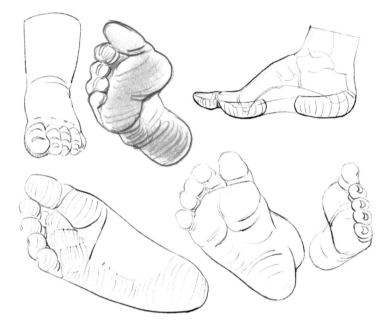

Fat

Once again, we find the same logic in the shape of the foot as in the shape of the hand. Subcutaneous fat lines the skin, and its thickness varies according to a person's weight. It mostly modifies the shape of the top of the foot, causing the heads of the metatarsals to appear at the bottom of a series of depressions, or dimples. An important cushion of fat on the bottom of the foot protects the muscles and the bones, reinforc-ing the foot's properties as a shock absorber while also increasing the foot's adherence to the ground.

Veins

Only the superficial veins, visible underneath the skin, are of interest to us here. The route they take is largely random. I present a "cartography" of only the most important veins, but note that this formulaic representation cannot entirely match reality.

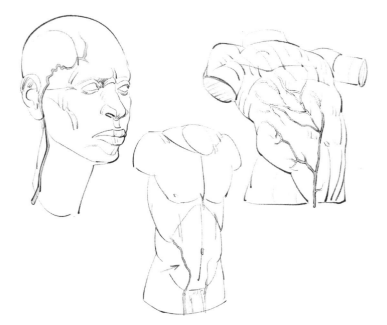

The veins vary in volume from one individual to the next, and even within the same individual. They dilate with the influx of blood, and they can become larger with regular and sustained exertion. They can take on a knotted look as they fold back upon themselves. They often communicate with each other and they form a web that contains uneven meshes.

The veins are particularly visible at the extremities, which is why we deal with them in this book. Because I didn't discuss veins in the earlier titles of this series, I will briefly present the most important veins that are visible on the head and the torso, as well.

In the area of the head and the neck, you can often see the temporal vein, which connects to the external jugular by cutting across the path of the sternocleidomastoid. From the angle of the jaw, it then slides into the depression behind the collarbone.

In the torso, we will deal with only one vein that is sometimes visible. The superficial epigastric vein starts at the lower abdomen and cuts through the crease of the groin to join the internal saphenous vein.

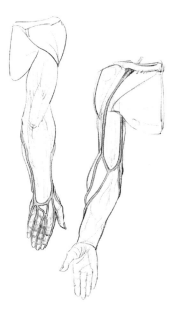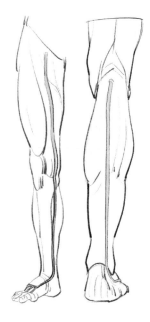

On the upper limb, the veins climb from the tips of the fingers and form a series of archways on the first phalanges, below the heads of the metacarpals, then they come back together on the back of the hand. There, they connect with each other and form an inverted archway. They then produce two branches that frame the forearm along its length, meeting at the hollow of the elbow.

At their beginning, on the fingers and hand, the veins are numerous and seem to follow a random course. As they climb toward the shoulder, they become more voluminous but fewer in number and are simpler in their appearance.

From the back of the fingers and hand, the veins twist along the sides of the forearm to connect at the in-side of the elbow. They then follow their climb on either side of the biceps in two venous lines. On the inner arm, the basilic vein disappears into the hollow of the armpit. On the outer arm, the cephalic vein slides between the deltoid and the pectoral to disappear into a depression beneath the collarbone.

On the lower limb, we find a similar pattern where the veins start on the back of the toes and the foot, form an archway, and then converge into two main venous lines. The long saphenous vein on the inner leg continues as far as the hip joint, following the path of the sartorius muscle along the thigh, while the external short saphenous vein stops at the back of the knee.

drawings

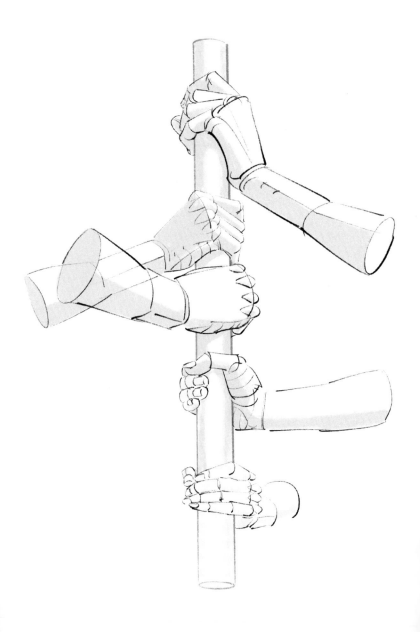

hands

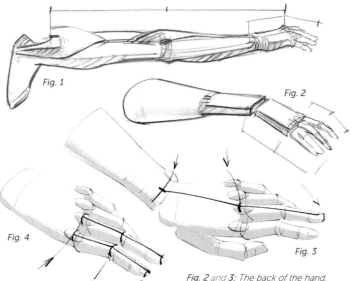

Fig. 1: The elbow joint is halfway between the top of the shoulder and the end of the back of the hand (the knuckles).

Fig. 2 and **3:** The back of the hand, measured from the end of the ulna (the bony protrusion on your wrist, on the little finger's side), is equal in length to the longest finger.

Fig. 2 and **4:** The first phalange of each finger (except for the thumb) is the same length as the next two phalenges combined.

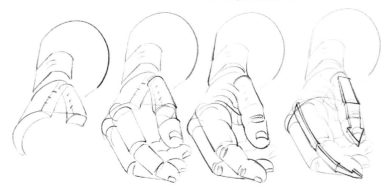

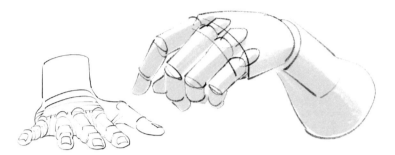

The back of the hand is flat; at rest, it is slightly curved. This part remains flexible and can become flatter or rounder. Each finger contains three phalanges. The thumb has only two, but the greater mobility of its metacarpal, which is independent starting from the wrist joint, gives the impression that the thumb, too, is made up of three mobile segments.

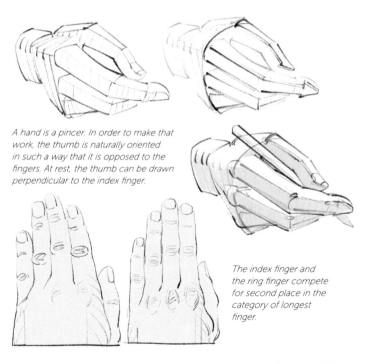

A hand is a pincer. In order to make that work, the thumb is naturally oriented in such a way that it is opposed to the fingers. At rest, the thumb can be drawn perpendicular to the index finger.

The index finger and the ring finger compete for second place in the category of longest finger.

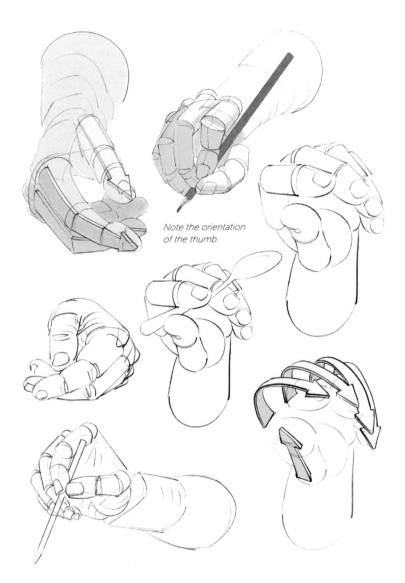

Note the orientation of the thumb.

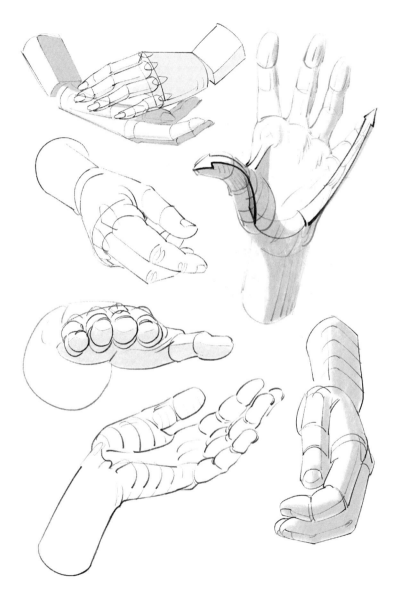

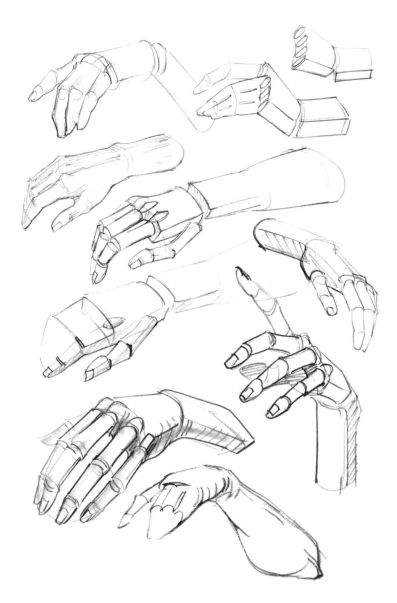

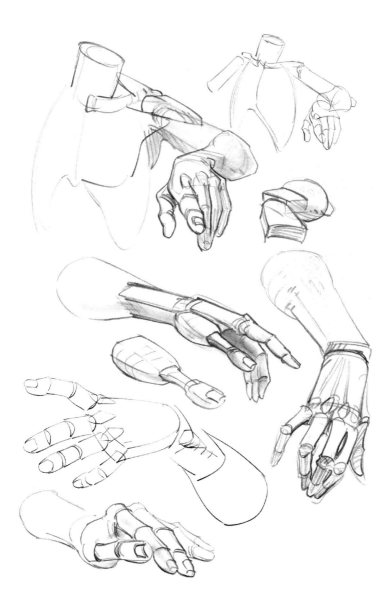

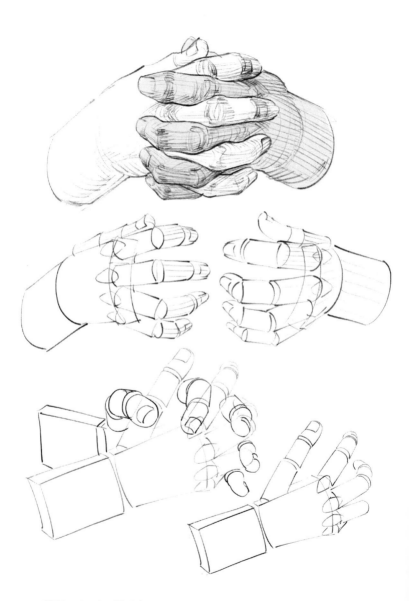

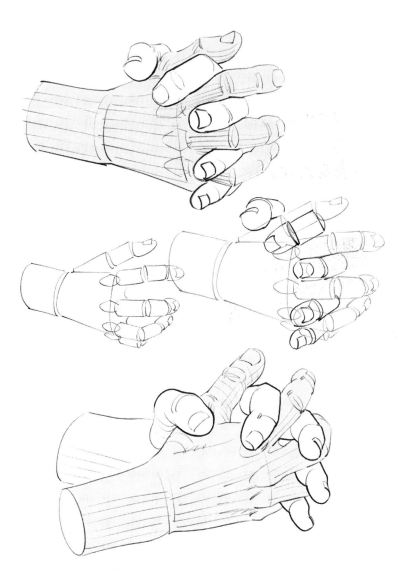

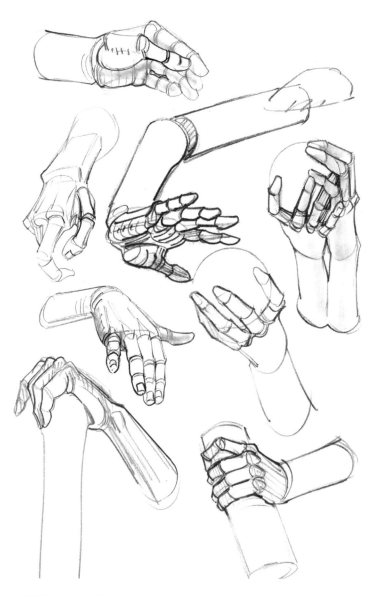

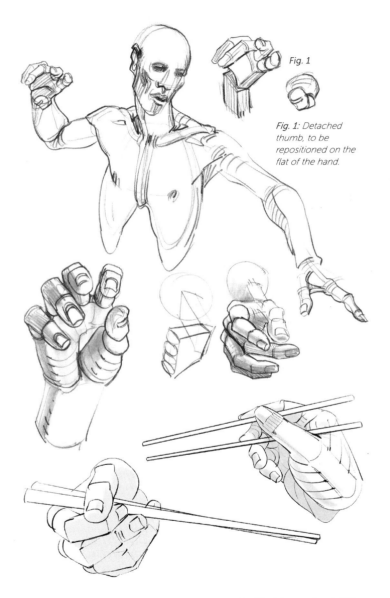

Fig. 1

Fig. 1: Detached thumb, to be repositioned on the flat of the hand.

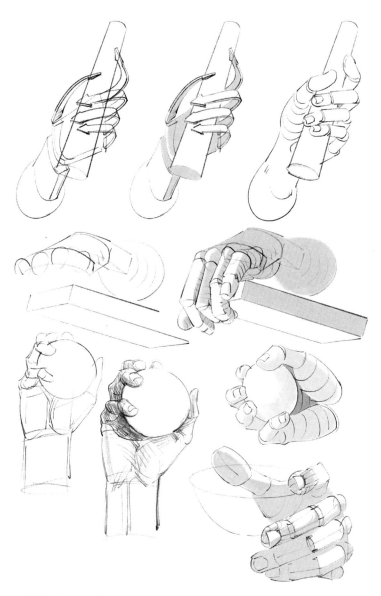

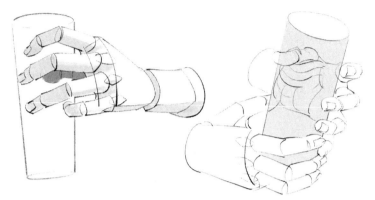

Each object has first been reduced to its simplified shape. The hands are drawn next, in such as a way as to make them best embrace the forms and to understand the hand in perspective.

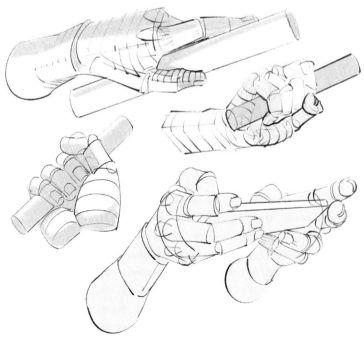

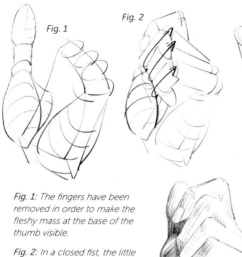

Fig. 1

Fig. 2

Fig. 1: The fingers have been removed in order to make the fleshy mass at the base of the thumb visible.

Fig. 2: In a closed fist, the little finger finds its place in the palm of the hand, while the other fingers, hampered by this muscular thickness, ride up closer to the thumb.

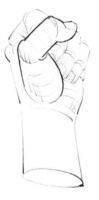

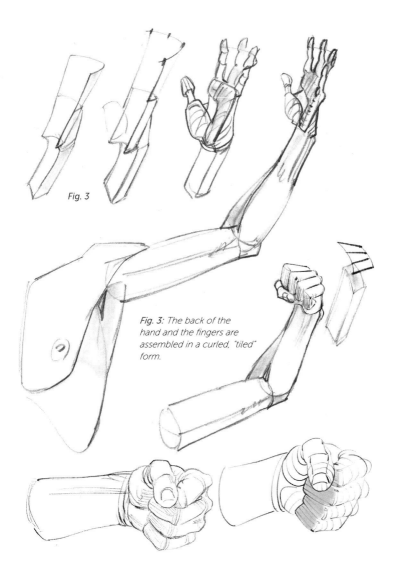

Fig. 3

Fig. 3: The back of the hand and the fingers are assembled in a curled, "tiled" form.

If you want to go further in your understanding of shapes, a detour through anatomy is necessary. Let us review a few notions. The hand's rotating motions take place at the elbow, on the humerus (Fig. 1). The hand is within the extension of the radius, which is parallel to the ulna (the elbow bone) during supination movements (Figs. 2 and 3) and crosses it during pronation (Figs. 4 and 5).

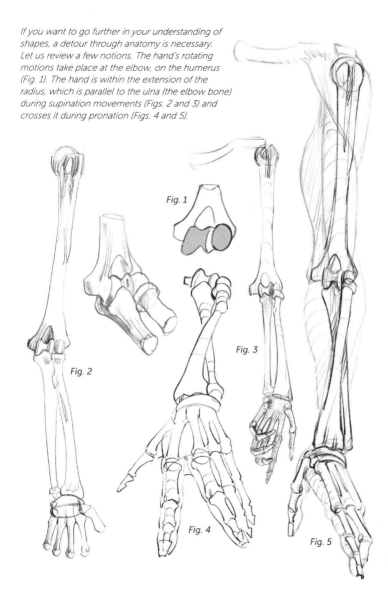

Fig. 1

Fig. 2

Fig. 3

Fig. 4

Fig. 5

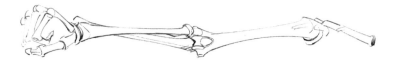

Eight small bones at the wrist create a base (Fig. 6) for the tendons of the flexors, which we will look at later. The edges of this base are visible at the heel of the hand (Figs. 7 and 8). The first bones of the fingers (the metacarpals) form the back of the hand, and aside from that of the thumb, which is more independent, they are not visible except at their extremities (in a fist).

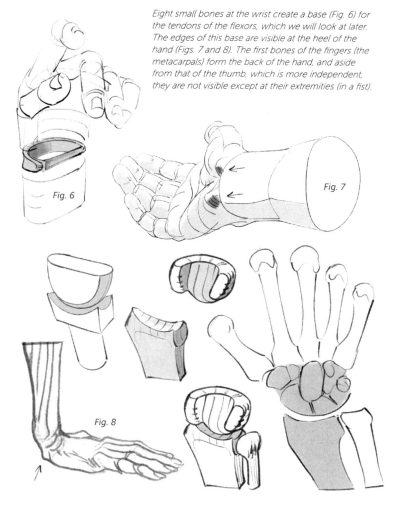

Fig. 6

Fig. 7

Fig. 8

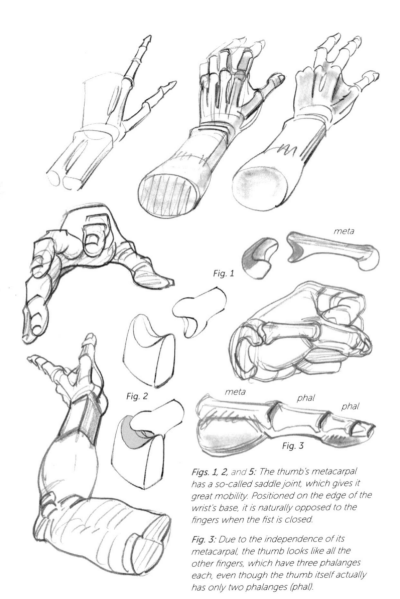

Fig. 1

meta

Fig. 2

meta *phal* *phal*

Fig. 3

Figs. 1, 2, and 5: The thumb's metacarpal has a so-called saddle joint, which gives it great mobility. Positioned on the edge of the wrist's base, it is naturally opposed to the fingers when the fist is closed.

Fig. 3: Due to the independence of its metacarpal, the thumb looks like all the other fingers, which have three phalanges each, even though the thumb itself actually has only two phalanges (phal).

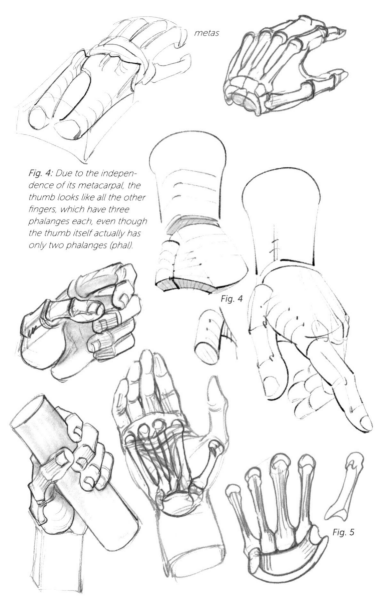

metas

Fig. 4: Due to the independence of its metacarpal, the thumb looks like all the other fingers, which have three phalanges each, even though the thumb itself actually has only two phalanges (phal).

Fig. 4

Fig. 5

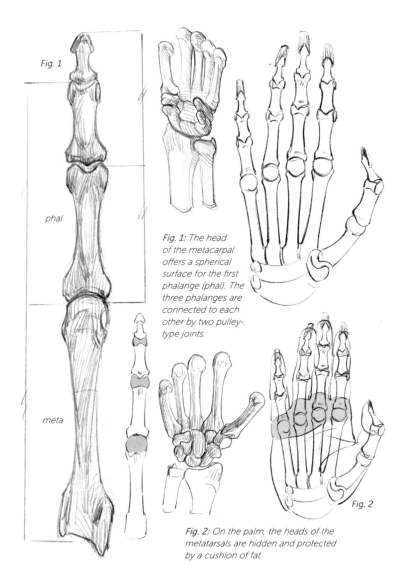

Fig. 1

phal

meta

Fig. 1: The head of the metacarpal offers a spherical surface for the first phalange (phal). The three phalanges are connected to each other by two pulley-type joints.

Fig. 2: On the palm, the heads of the metatarsals are hidden and protected by a cushion of fat.

Fig. 2

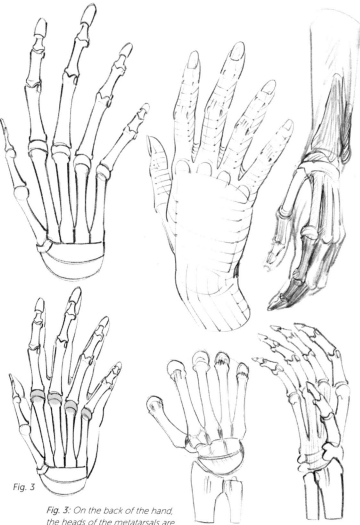

Fig. 3

Fig. 3: On the back of the hand, the heads of the metatarsals are clearly visible under the skin.

The offset, mobile thumb is clearly distinguished from the fingers.

The metacarpals of the fingers make up the united plane of the back of the hand and can be seen along the line of the closed fist. The spherical heads of each metacarpal creates protrusions along the axis of the fingers. Between the phalanges, the pulley-type joints can be seen in the form of two lateral projections and a central gorge along the axis.

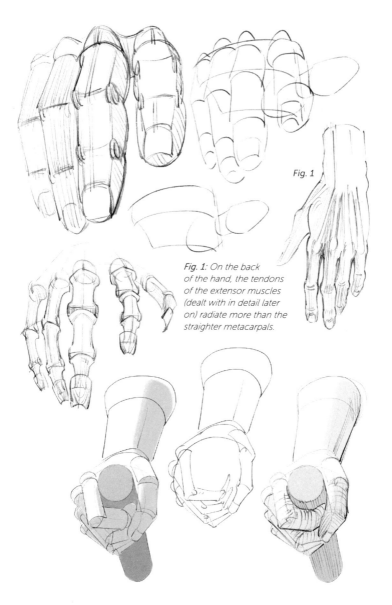

Fig. 1

Fig. 1: On the back of the hand, the tendons of the extensor muscles (dealt with in detail later on) radiate more than the straighter metacarpals.

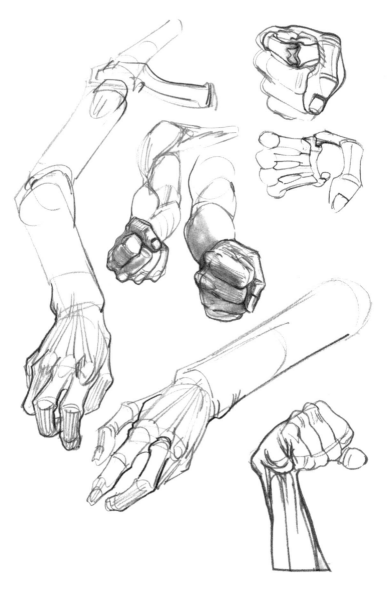

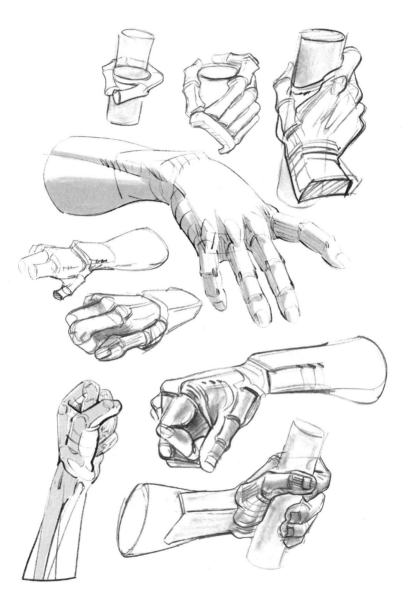

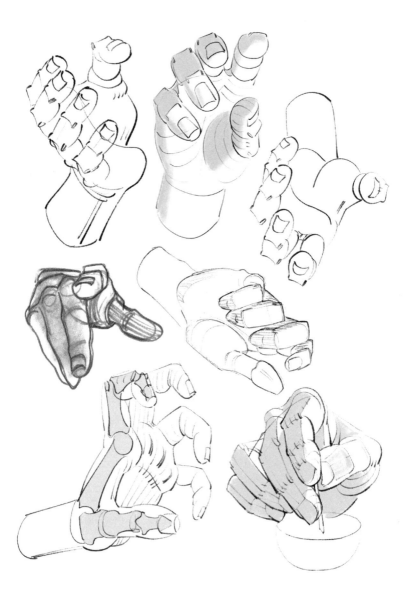

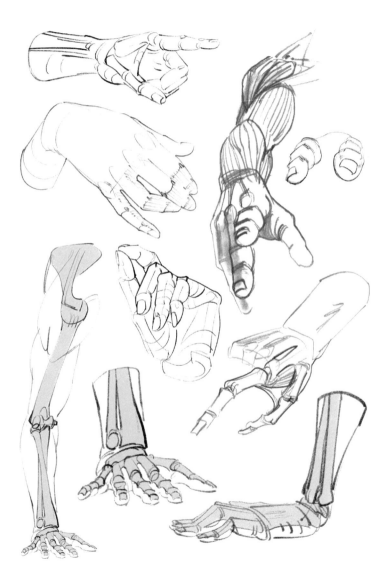

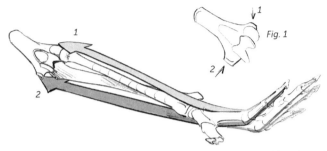

Fig. 1

We will now look at the musculature, and in order to do this, we need to go further up the arm. Almost all of the muscular mass of the forearm is devoted to controlling the hand. The extensors (1) and flexors (2) start at the humerus (Fig.1) and then reconnect, respectively, with the back and the palm of the hand, down to the ends of the fingers.

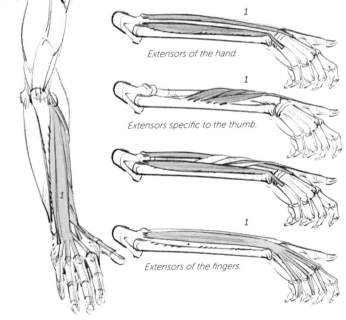

Extensors of the hand.

Extensors specific to the thumb.

Extensors of the fingers.

Fig. 2

Fig. 2: The lateral bundles of the extensors and flexors lead to the hand along the side of the forearm.

Fig. 3: The flexors of the fingers are divided into two layers that take turns in an interesting way at the tip of the fingers.

Fig. 3

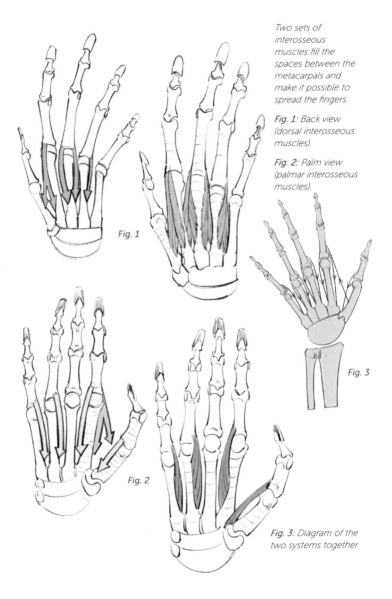

Two sets of interosseous muscles fill the spaces between the metacarpals and make it possible to spread the fingers.

Fig. 1: *Back view (dorsal interosseous muscles).*

Fig. 2: *Palm view (palmar interosseous muscles).*

Fig. 1

Fig. 2

Fig. 3

Fig. 3: Diagram of the two systems together.

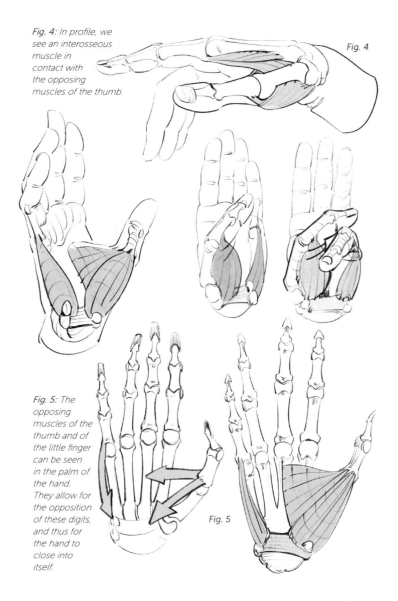

Fig. 4: In profile, we see an interosseous muscle in contact with the opposing muscles of the thumb.

Fig. 4

Fig. 5: The opposing muscles of the thumb and of the little finger can be seen in the palm of the hand. They allow for the opposition of these digits, and thus for the hand to close into itself.

Fig. 5

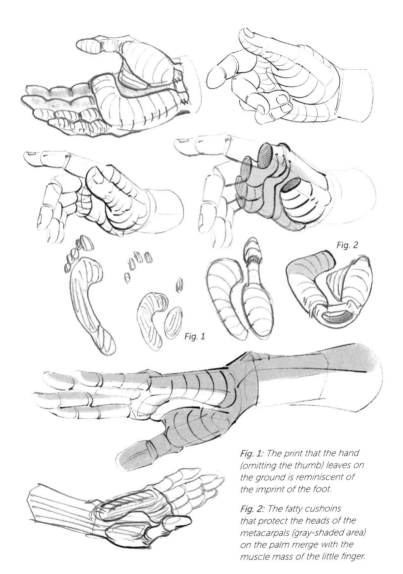

Fig. 1: The print that the hand (omitting the thumb) leaves on the ground is reminiscent of the imprint of the foot.

Fig. 2: The fatty cushoins that protect the heads of the metacarpals (gray-shaded area) on the palm merge with the muscle mass of the little finger.

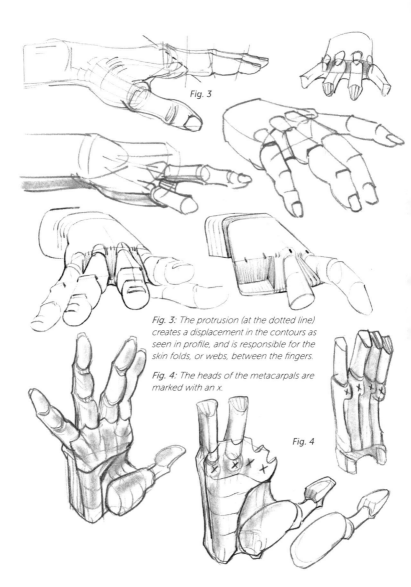

Fig. 3: The protrusion (at the dotted line) creates a displacement in the contours as seen in profile, and is responsible for the skin folds, or webs, between the fingers.

Fig. 4: The heads of the metacarpals are marked with an x.

Fig. 3

Fig. 4

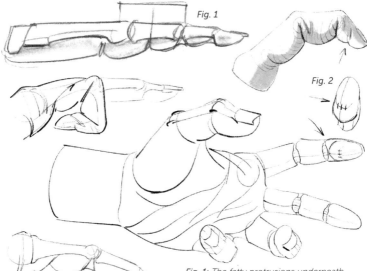

Fig. 1

Fig. 2

Fig. 3

Fig. 4

Fig. 1: The fatty protrusions underneath the heads of the metacarpals overlap with half of a phalanges. As a result, the fingers look shorter when they are seen from below.

Fig. 2: An additional little fold is caused by the tension of the skin around the pad of fat at the end of the fingers during flexion.

Fig. 3: Flexion folds and "bellows" underneath the joints.

Fig. 4: Fatty volumes under the tips of the fingers.

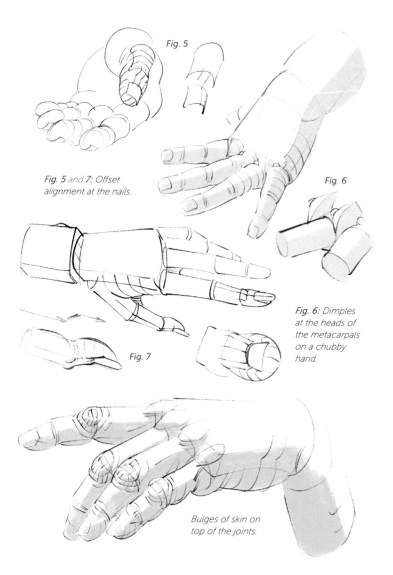

Fig. 5

Fig. 5 and 7: Offset alignment at the nails.

Fig. 6

Fig. 6: Dimples at the heads of the metacarpals on a chubby hand.

Fig. 7

Bulges of skin on top of the joints.

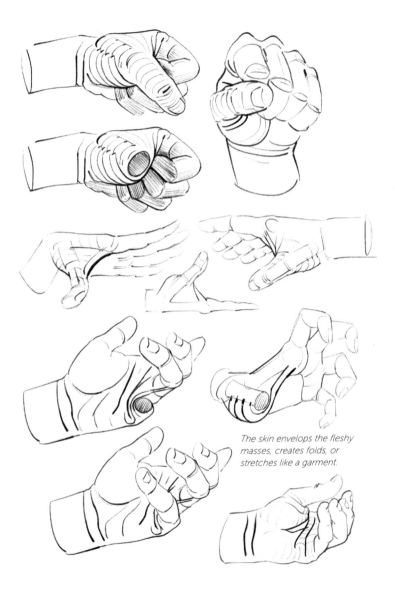

The skin envelops the fleshy masses, creates folds, or stretches like a garment.

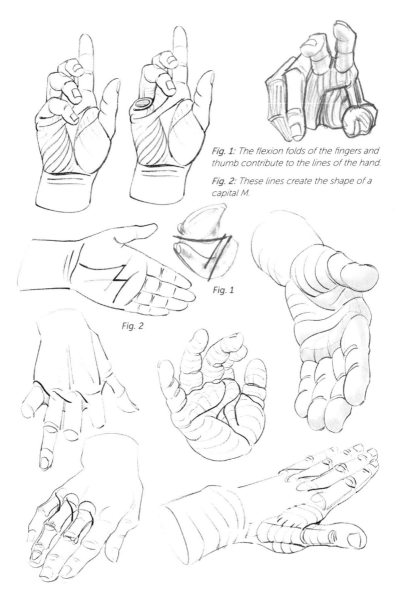

Fig. 1: The flexion folds of the fingers and thumb contribute to the lines of the hand.

Fig. 2: These lines create the shape of a capital M.

Fig. 1

Fig. 2

Fig. 1: The fat on the palm of the hand and on the fingers gives the hand a good grip, allowing it to form itself to the shapes of the objects it grasps.

Fig. 2: Dimples on the heads of the metacarpals, due to fat. Here the skin is attached to the skeleton much like quilting points.

Fig. 3: Extension folds.

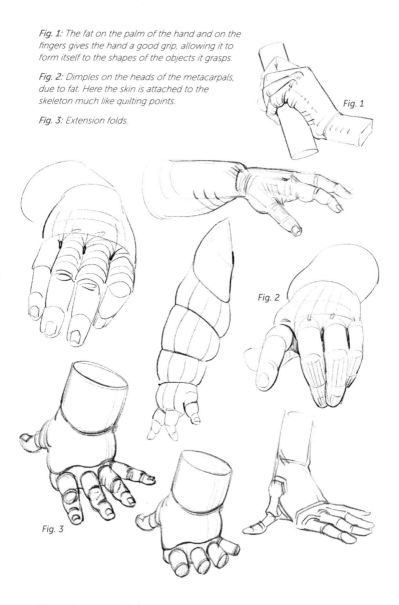

Fig. 1

Fig. 2

Fig. 3

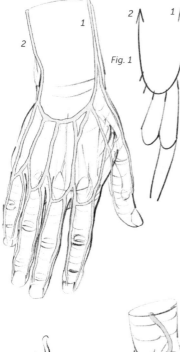

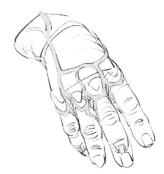

Fig. 1

Fig. 1: *Starting at the tips of the fingers, the veins climb, drawing a series of archways on the first phalange, underneath the heads of the metacarpals. They reconnect again on the back of the hand, where they join to form an inverted archway. They produce two branches: the radial vein on the side of the radius (1) and the ulnar vein on the side of the ulna (2).*

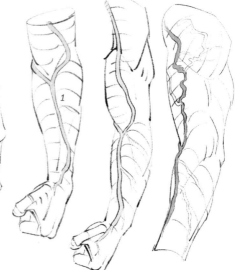

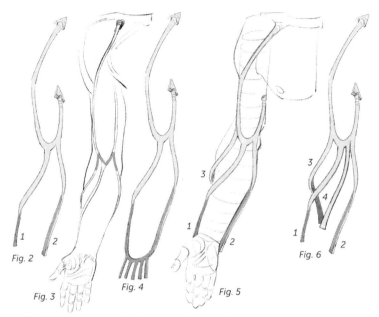

Fig. 2: These two veins then frame the limb along its entire length, meeting halfway at the hollow of the elbow, and then, changing their names at this point, they continue their climb on each side of the biceps. On the inside, the basilic vein disappears into the hollow of the armpit. On the outside, the cephalic vein slides between the deltoid and the pectoral to disappear into a depression beneath the collarbone.

Fig. 3: The "classical" version draws the shape of a capital M on the inside of the elbow.

Fig. 4: From the backs of the fingers and the hand, the veins twist along the sides of the forearm to reconnect with each other at the front of the elbow.

Fig. 5 and 6: Here, we can place two more veins that connect with the previous ones: one (3) that starts at the back of the forearm, and the other (4) that starts from the front of the forearm.

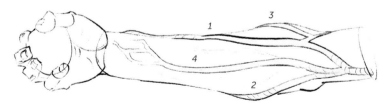

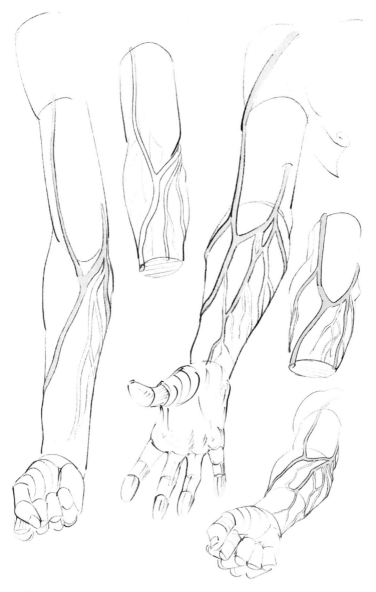

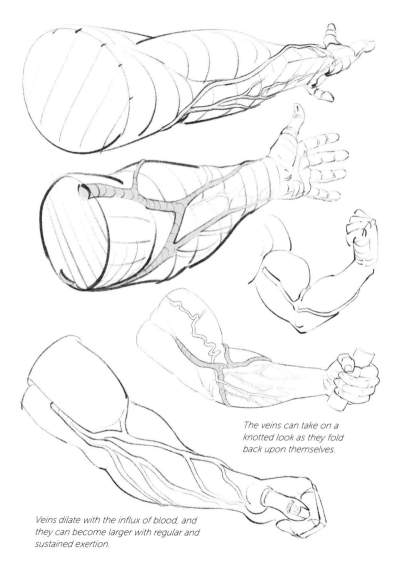

The veins can take on a knotted look as they fold back upon themselves.

Veins dilate with the influx of blood, and they can become larger with regular and sustained exertion.

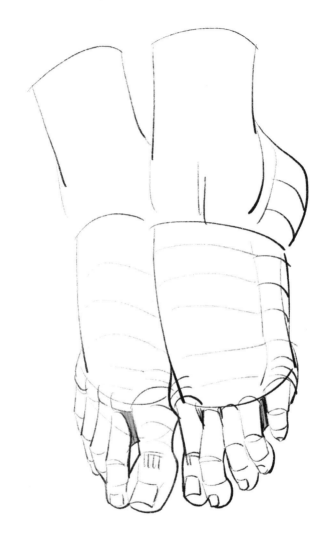

feet

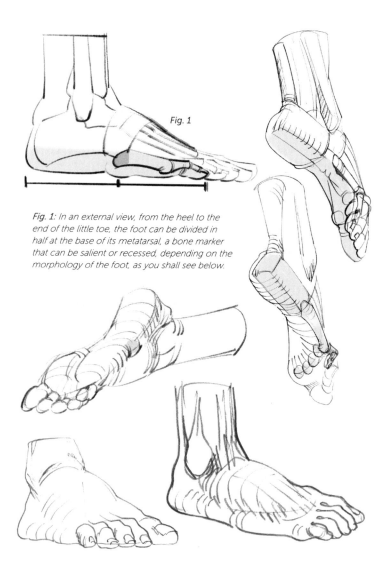

Fig. 1: In an external view, from the heel to the end of the little toe, the foot can be divided in half at the base of its metatarsal, a bone marker that can be salient or recessed, depending on the morphology of the foot, as you shall see below.

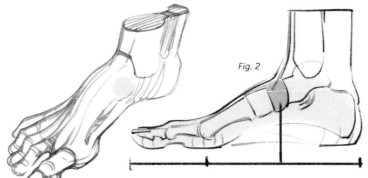

Fig. 2: As viewed from the inside, from the heel to the end of the big toe, the foot can be divided into three equal parts. Starting with the heel, the first section ends at the navicular bone (the keystone of the plantar arch); the second section ends at the head of the metatarsal, here pressing on the ground; and the third section corresponds to the toes.

The length of the toes is variable. The common designations include the Egyptian foot, of which all the toes can be seen in a profile view (Fig. 3); the Greek foot, where the big toe is shorter than the second toe (Fig. 4); and the square foot (Fig. 5).

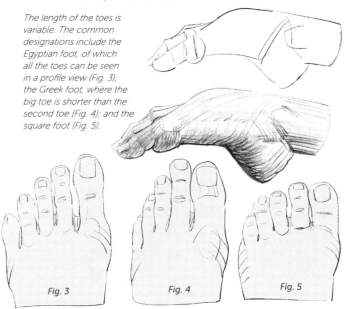

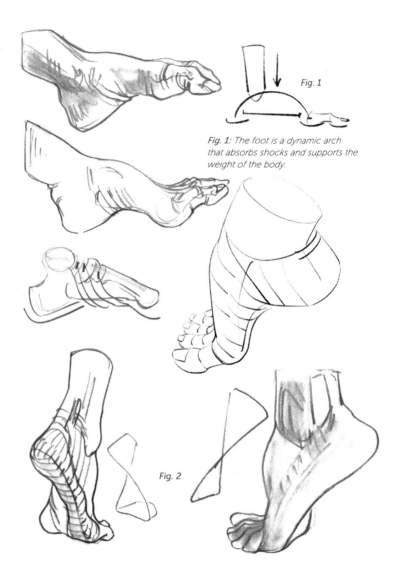

Fig. 1

Fig. 1: The foot is a dynamic arch that absorbs shocks and supports the weight of the body.

Fig. 2

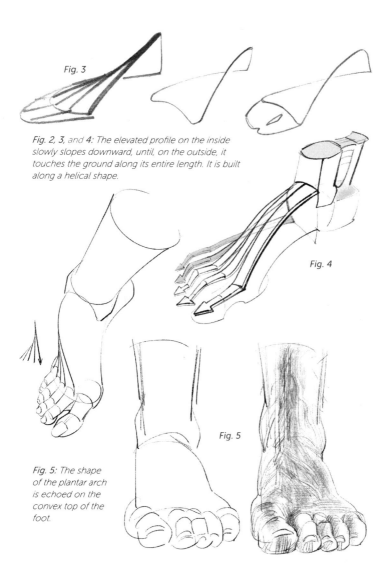

Fig. 3

Fig. 2, 3, and 4: The elevated profile on the inside slowly slopes downward, until, on the outside, it touches the ground along its entire length. It is built along a helical shape.

Fig. 4

Fig. 5

Fig. 5: The shape of the plantar arch is echoed on the convex top of the foot.

Fig. 1: The bottom of the foot rests against its entire outer edge, the heads of the metatarsals, and the tips of the toes.

Fig. 2: The footprint of a cavus (high-arched) foot shows the heel is separated from the front of the foot.

Fig. 3: The footprint of a flat foot. The plantar arch is collapsed and the footprint spills out toward the inside.

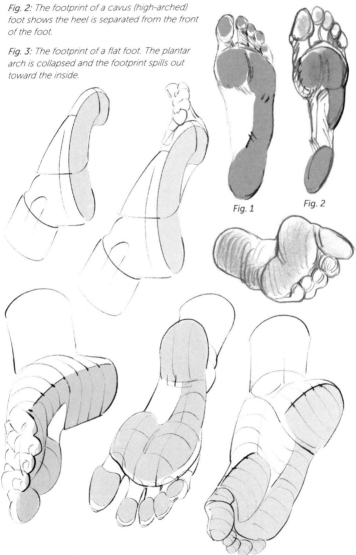

Fig. 1

Fig. 2

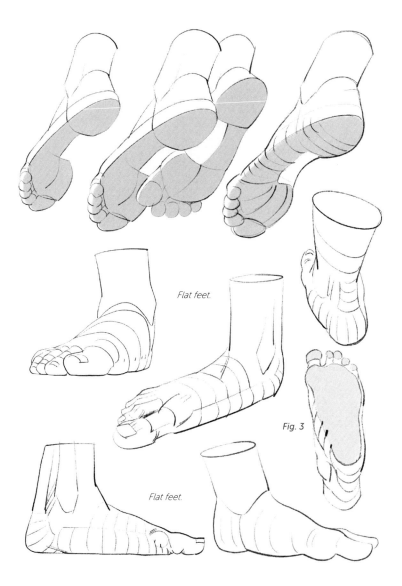

Flat feet.

Fig. 3

Flat feet.

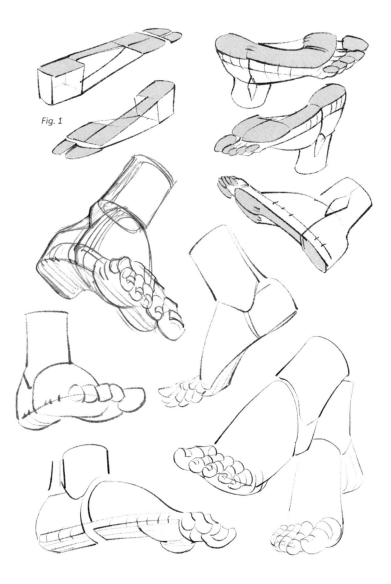

Fig. 1

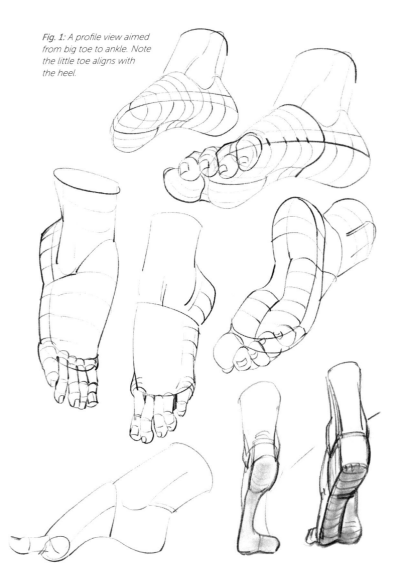

Fig. 1: A profile view aimed from big toe to ankle. Note the little toe aligns with the heel.

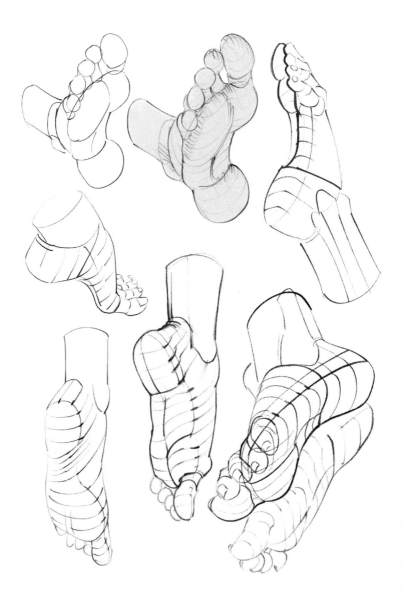

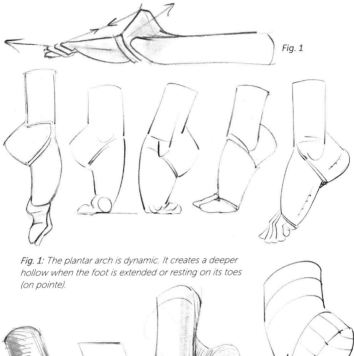

Fig. 1: The plantar arch is dynamic. It creates a deeper hollow when the foot is extended or resting on its toes (on pointe).

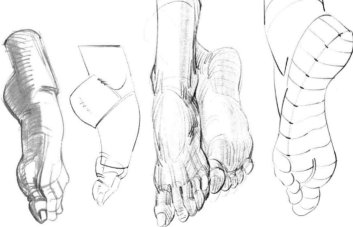

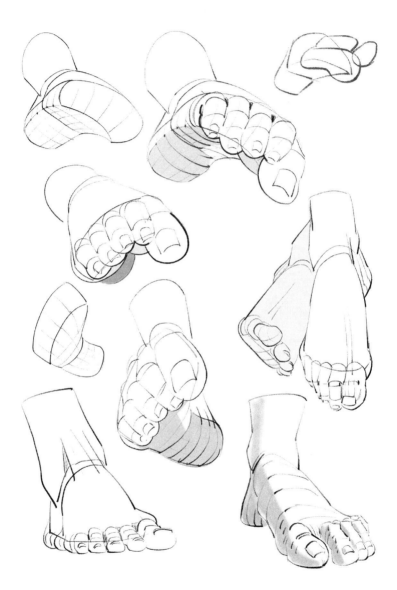

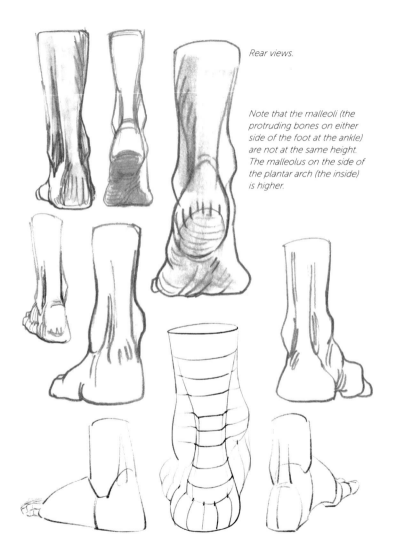

Rear views.

Note that the malleoli (the protruding bones on either side of the foot at the ankle) are not at the same height. The malleolus on the side of the plantar arch (the inside) is higher.

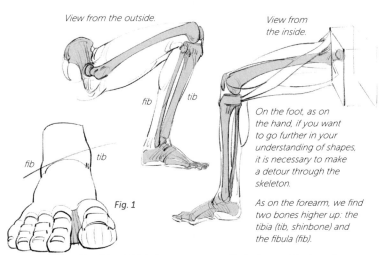

View from the outside.

View from the inside.

fib tib

fib tib

Fig. 1

On the foot, as on the hand, if you want to go further in your understanding of shapes, it is necessary to make a detour through the skeleton.

As on the forearm, we find two bones higher up: the tibia (tib, shinbone) and the fibula (fib).

The tibia, which is larger, connects with the femur at the knee. It is subcutaneous along its whole length and becomes the internal malleolus at the ankle.

The fibula is visible only at its extremities and creates the external malleolus.

Fig. 1 *and* **2**: *Note the heights of the malleoli.*

Fig. 2

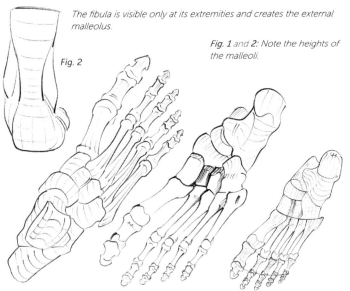

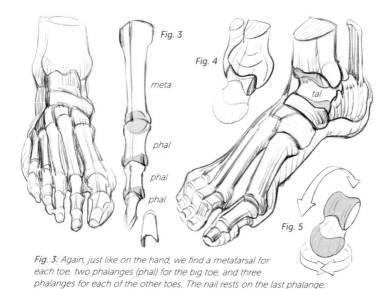

Fig. 3

meta

phal

phal

phal

Fig. 4

tal

Fig. 5

Fig. 3: *Again, just like on the hand, we find a metatarsal for each toe, two phalanges (phal) for the big toe, and three phalanges for each of the other toes. The nail rests on the last phalange.*

Fig. 4: *The talus (tal) is the recipient of the tibia and of the weight of the body. The tibia and the fibula frame it, forming a pincer.*

Fig. 5: *The talus brings together two types of joints: a pulley for the movements of flexion and extension underneath the leg, and a sphere for twists at the instep. These two types of joints can be found again on each toe (Fig. 3): a sphere at the head of the metatarsals (corresponding to the end of the fist on the hand) and a pulley between each two phalanges, which can be seen on the back of the toes when they are flexed (Fig. 6).*

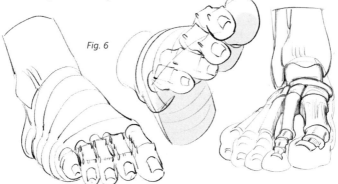

Fig. 6

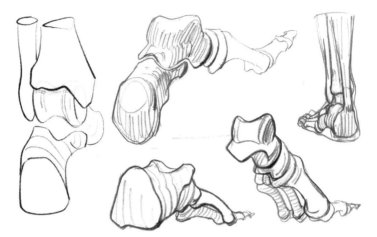

Earlier, we saw that the foot is raised along the dynamic, interior side but is in contact with the ground along its entire length on the static, exterior side.

Each of these corresponds to a series of bones, which converge at the heel.

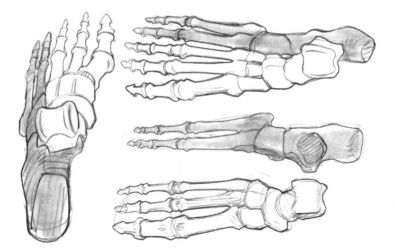

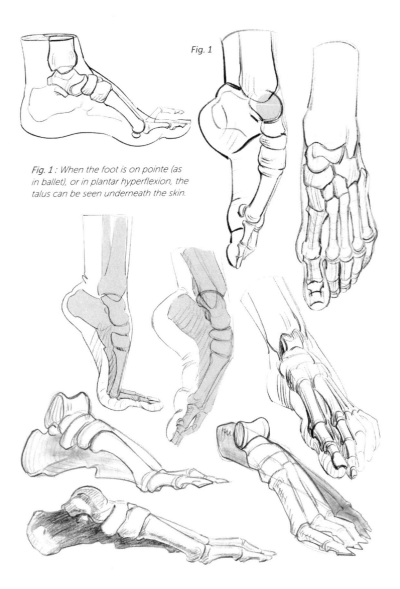

Fig. 1

Fig. 1 : When the foot is on pointe (as in ballet), or in plantar hyperflexion, the talus can be seen underneath the skin.

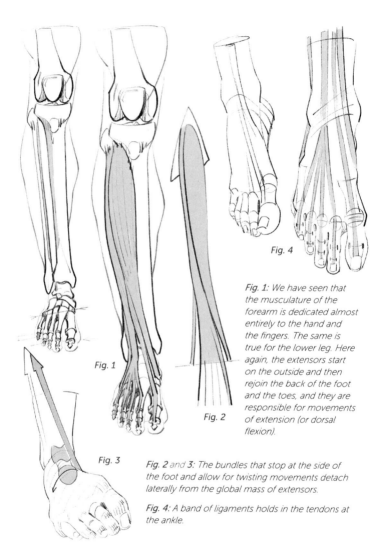

Fig. 1: We have seen that the musculature of the forearm is dedicated almost entirely to the hand and the fingers. The same is true for the lower leg. Here again, the extensors start on the outside and then rejoin the back of the foot and the toes, and they are responsible for movements of extension (or dorsal flexion).

Fig. 2 and **3:** The bundles that stop at the side of the foot and allow for twisting movements detach laterally from the global mass of extensors.

Fig. 4: A band of ligaments holds in the tendons at the ankle.

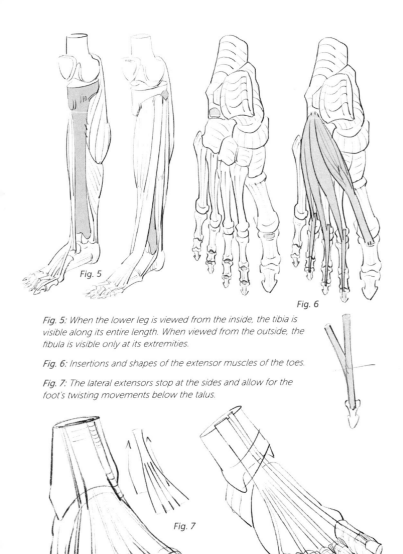

Fig. 5: When the lower leg is viewed from the inside, the tibia is visible along its entire length. When viewed from the outside, the fibula is visible only at its extremities.

Fig. 6: Insertions and shapes of the extensor muscles of the toes.

Fig. 7: The lateral extensors stop at the sides and allow for the foot's twisting movements below the talus.

Fig. 5

Fig. 6

Fig. 7

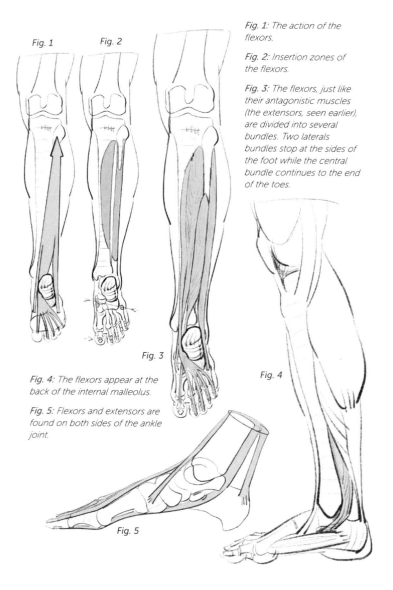

Fig. 1: The action of the flexors.

Fig. 2: Insertion zones of the flexors.

Fig. 3: The flexors, just like their antagonistic muscles (the extensors, seen earlier), are divided into several bundles. Two laterals bundles stop at the sides of the foot while the central bundle continues to the end of the toes.

Fig. 1

Fig. 2

Fig. 3

Fig. 4: The flexors appear at the back of the internal malleolus.

Fig. 5: Flexors and extensors are found on both sides of the ankle joint.

Fig. 4

Fig. 5

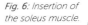

Fig. 6: Insertion of the soleus muscle.

Fig. 7: The soleus muscle is found within the deep bundle of the triceps surae.

Fig. 8: The action of the triceps.

Fig. 9: The gastrocnemius muscle, super-imposed on the soleus, also attaches to the heel. Along with the soleus, they form the triceps surae.

Fig. 10: Insertion points of the gastrocnemius.

Fig. 11: The extensors that are opposed to the triceps.

Fig. 12: The flexors slip in between the two extensors shown in Fig. 11.

Fig. 13: The external malleolus (at the bottom of the fibula) sits between the flexors and the extensors.

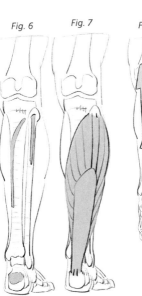

Fig. 6

Fig. 7

Fig. 8

Fig. 9

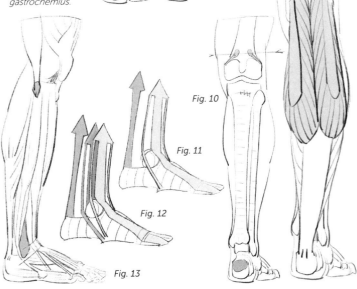

Fig. 10

Fig. 11

Fig. 12

Fig. 13

Fig. 1: *Insertion and shape of the plantar flexor.*

Fig. 2: *Tendinous handoff between this muscle, which divides itself in half, and the end of the toe flexor (see p. 84), which moves through the divided muscle.*

Fig. 3: *Action of the interosseous plantar and dorsal muscles.*

Fig. 4: *Insertion and shape of the interosseous muscles.*

Fig. 5: *Action of the big toe adductor and the little toe abductors.*

Fig. 6: *Insertion and shape of the big toe adductor and the little toe abductors.*

Fig. 7: *Fat largely hides this musculature. The big toe adductor is the only one that is visible here.*

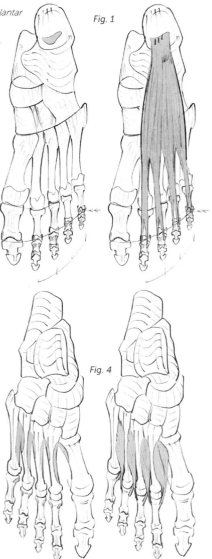

Fig. 1

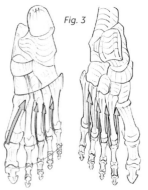

Fig. 2

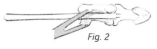

Fig. 3

Fig. 4

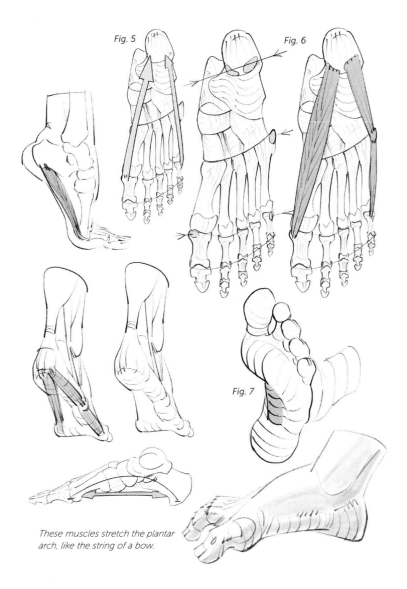

Fig. 5

Fig. 6

Fig. 7

These muscles stretch the plantar arch, like the string of a bow.

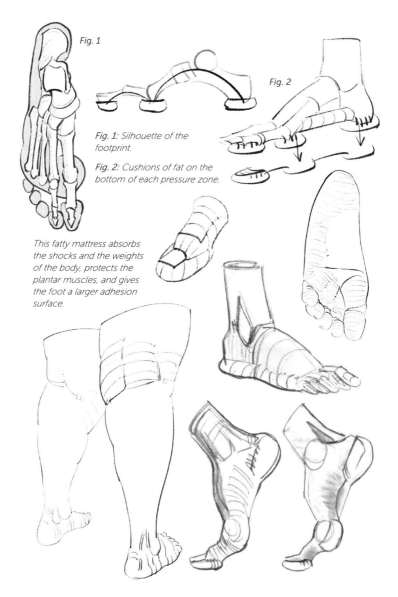

Fig. 1

Fig. 2

Fig. 1: Silhouette of the footprint.

Fig. 2: Cushions of fat on the bottom of each pressure zone.

This fatty mattress absorbs the shocks and the weights of the body, protects the plantar muscles, and gives the foot a larger adhesion surface.

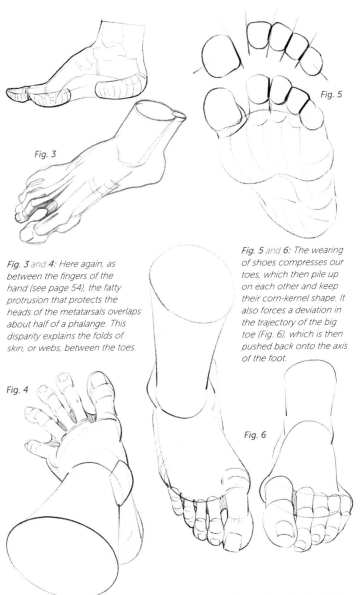

Fig. 3 and **4**: Here again, as between the fingers of the hand (see page 54), the fatty protrusion that protects the heads of the metatarsals overlaps about half of a phalange. This disparity explains the folds of skin, or webs, between the toes.

Fig. 5 and **6**: The wearing of shoes compresses our toes, which then pile up on each other and keep their corn-kernel shape. It also forces a deviation in the trajectory of the big toe (Fig. 6), which is then pushed back onto the axis of the foot.

Fig. 3

Fig. 5

Fig. 4

Fig. 6

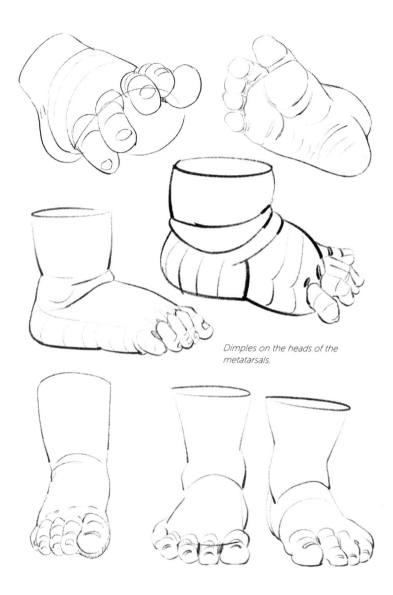

Dimples on the heads of the metatarsals.

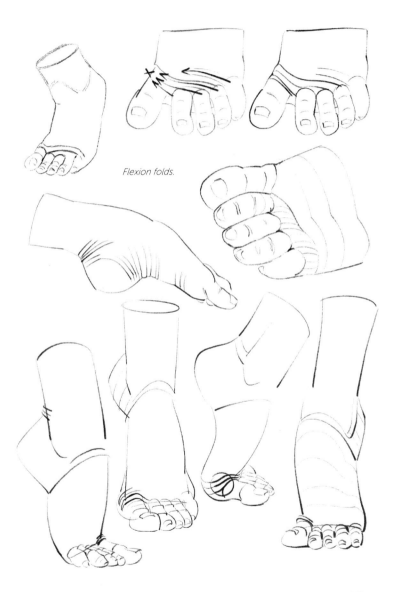

Flexion folds.

For the foot, we can reuse the diagram we used for the network of veins on the hand, because here, again, the veins climb from the ends of the toes and come together, in a large number, in a dorsal arch that is convex in front and that intersects with the metatarsals.

This arch extends backward and is the beginning point of two important veins that climb up along the leg.

On the inside, the great saphenous vein (1) passes in front of the internal malleolus, runs along the shinbone (tibia), slides behind the femoral condyle at the knee, and runs up the thigh on the diagonal (parallel to the sartorius muscle). It then plunges below the surface in the hollow of the groin.

On the outside, the short saphenous vein (2) passes behind the external malleolus, climbs along the back of the leg, connects with the medial axis (between the gemellus muscles), and then plunges below the surface in the hollow of the shin (popliteal fossa).

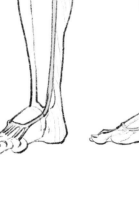

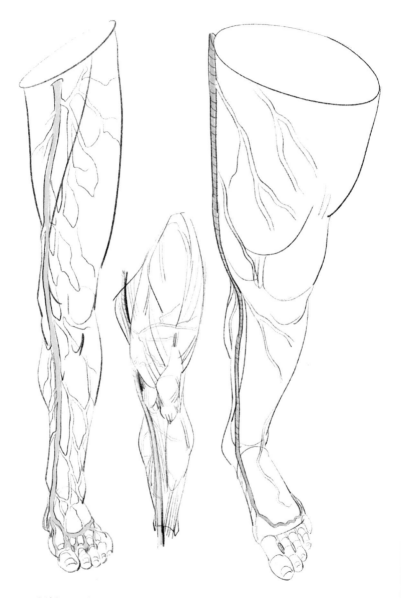

Internal views.

Remember that in order to create these diagrams, or "maps," of the venal network, I had to select from among an infinite number of variations.

The drawings in this book, therefore, illustrate just a general view and are intended to satisfy a mnemonic need connected with drawing from your imagination.

resources

George B. Bridgman, *Constructive Anatomy*, Dover Publications, Inc., New York, 1972

George B. Bridgman, *The Human Machine*, Dover Publications, Inc., New York, 1972

Paul Richer, *Artistic Anatomy*, Watson-Guptill, New York, 1986

Sarah Simblet and John Davis, *Anatomy for the Artist*, DK Publishing, London, 2001

For French speakers (from the original French edition):

Bibliothèque nationale de France, Bibliothèque numérique Gallica [en ligne], www.gallica.bnf.fr

Henri Rouvière and André Delmas, *Anatomie humaine*, Paris, Masson, 1984

Paul Richer, *Canon des proportions du corps humain*, Librairie Ch. Delagrave, Paris 1893.

Thomas Wienc, *Le dessin de nu : anatomie et modèle vivant*, Dessin et Tolra, Paris, 2010

Werner Platzer, *Atlas de poche Anatomie*, Lavoisier médecine, France, 2014

abbreviations

rad: radius
uln: ulna
fib: fibula
tib: tibia

meta: metacarpal
phal: phalange
tal: talus